"Moving" with Mattie Lou O'Kelley

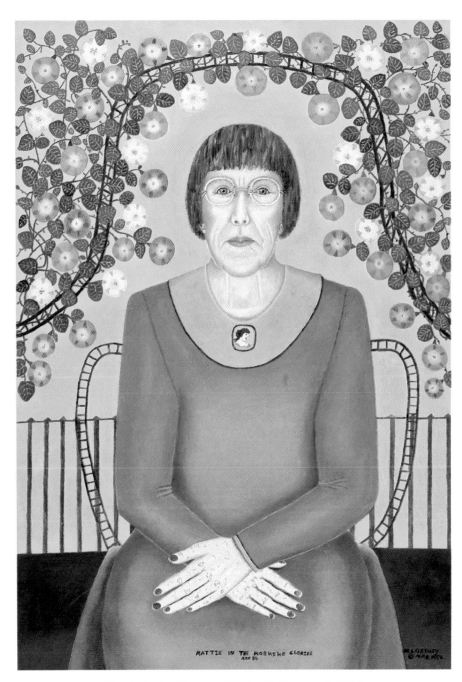

Mattie in the Morning Glories. Self-portrait, 1992.

"Moving" with Mattie Lou O'Kelley

By Barbara R. Luck

The Colonial Williamsburg Foundation
Williamsburg, Virginia

Library of Congress Cataloging-in-Publication Data

Luck, Barbara.
 "Moving" with Mattie Lou O'Kelley / by Barbara R. Luck.
 p. cm.
 Catalog of an exhibition held at the Abby Aldrich Rockefeller Folk Art Center.
 Includes bibliographical references.
 ISBN 0-87935-156-X
 1. O'Kelley, Mattie Lou—Exhibitions. 2. O'Kelley, Mattie Lou. Moving to town—
Illustrations—Exhibitions. 3. Moving, Household, in art—Exhibitions. 4. City and town life
in art—Exhibitions. I. O'Kelley, Mattie Lou. II. Abby Aldrich Rockefeller Folk Art Center.
III. Title.
ND237. 0515A4 1995
759. 13—dc20

 95-11614
 CIP

Book design: Vernon Wooten

Printed in Hong Kong

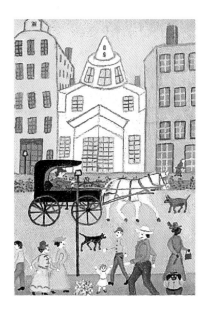

This catalog, and the exhibit it accompanies, would not have been possible without the kindness, perseverance, and contagious enthusiasm of T. Marshall Hahn, Jr. As a long-standing friend of Mattie Lou O'Kelley's and a fervent admirer of her colorful, highly patterned paintings, Mr. Hahn has been tireless in his efforts to bring the artist and her work the widespread recognition they so richly deserve. The Abby Aldrich Rockefeller Folk Art Center and its numerous visitors have been the latest beneficiaries of those efforts.

In addition to helping fund this catalog, providing its illustrative materials, and reviewing its manuscript, Mr. Hahn has loaned the Folk Art Center all of the paintings shown in the catalog for display in Williamsburg for an extended period in 1995.

Additional funding for this catalog has been generously provided by the Georgia-Pacific Corporation and the Norfolk Southern Corporation. The Folk Art Center is deeply indebted to these two organizations and to Mr. Hahn for making it possible to share with a broader audience the delightful paintings of artist Mattie Lou O'Kelley.

"Moving" with Mattie Lou O'Kelley

As adults, most of us have forgotten our childhood impressions of the cavernous spaciousness of grownup-sized households, the exhilaration of jumping on mattresses, the mesmerizing quality of fast-paced urban lifestyles, and the near-insupportable anxiety of waiting for Christmas. We have also forgotten that Santa Claus is larger than life, that trains are visible in rainbows, and that children, like dreamers, give literal meaning to symbols.[1] Some of us adults have also learned to take for granted the pleasing qualities of order, rhythm, and pattern imposed on the environment by our minds and hands, not to mention the marvel and beauty of the natural world. Perhaps saddest of all, some of us have forgotten—or never experienced—the comfort, security, companionship, and nurturing love provided by close family relationships.

Such child-experienced truths are compellingly captured by the twenty-four "Moving" pictures of Georgia artist Mattie Lou O'Kelley (b. 1908), making them accurate personal recollections in an elemental sense, even when their narrative vehicle springs from the artist's fertile imagination. In the best mythmaking tradition, O'Kelley acknowledges the inadequacy of factual nuts and bolts in describing larger realities.

O'Kelley's series of "Moving" pictures was created in 1987–1989 to illustrate a children's book, *Moving to Town*, which O'Kelley also wrote using a quasi-autobiographical storyline.[2] Both words and pictures tell the tale of a family who abandon their farm for life in the city, then return to their country home less than a year later. O'Kelley narrates the story in first person, as a preadolescent child, and the specific names and relationships of her real-life family of origin are maintained throughout the se-

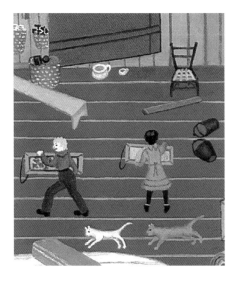

quence. The plausible, commonplace nature of the numerous activities that, together, make up the moves is convincing. Such realities, coupled with a plethora of minute details and believable early twentieth-century rural Georgia phrases ("fizzing to get there," "a real buster"), suggest that the O'Kelley family actually *did* try life in "the city" for awhile. However, the O'Kelleys only tasted urban life on occasional visits, and the book family's moves back and forth are simply a fictionalized framework. That fact should not obscure or detract from O'Kelley's compelling rendering of the realities of a child's excitement and astonishment at discovering the larger world.[3]

The twenty-four "Moving" pictures constitute only a small percentage of the total number of paintings O'Kelley created in her lifetime.[4] They form a cohesive, sequential unit by virtue of the continuous thread of their storyline, but each can also stand alone, and each is stylistically typical of the majority of the artist's works, which are more patently autobiographical.

O'Kelley is usually categorized as a "memory" painter. Recollections of her childhood in rural northeast Banks County, Georgia, as the seventh of eight children born to a farming couple form the dominant theme of her artwork. Descriptions of her paintings usually dwell on this personal, narrative aspect but all too often give short shrift to their fantastical quirks, their historical value, and their delightful decorative qualities. Nor are explanations usually offered as to how these sometimes contradictory characterizations might coexist and overlap in her creations.[5]

Memory painters are often dismissed as sentimental nostalgics when they are perceived as viewing the past through rose-colored glasses, as O'Kelley is often said to do. The artist's "Moving" paintings make no allusions to such common childhood experiences as loneliness, pain, helplessness, grief, and terror. Few of her more concretely autobiographical works do, either.[6] (Those that depict "boogers" or whippings, for instance, are made enchanting rather than horrific by O'Kelley's colorful, characteristic stylizations. And her narrative often detraumatizes such an event,

making a whipping, for instance, relatively unimportant: "but Mama said we could still go to the circus!")[7] Similarly, O'Kelley's environments, whether urban or rural, are invariably colorful, clean, and orderly, and even disasters like collapsed bridges and runaway horses assume the storybook inevitability of happy endings.[8] Fantasy?

Indeed. But—some would argue—fantasy in the most welcome sense. In a world where the nightly newscast is a grim litany of mutual human intolerance and environmental desecration, one can hardly be blamed for embracing the respite offered by O'Kelley's views, for we all need balance in our lives. Neither can one summarily dismiss O'Kelley's cheerful scenes as mere escapism, for portrayals like hers can help us visualize desperately needed ideals. While hard-bitten realists may scoff at ideals because they are so often impractical and unattainable, their conceptualization provides direction in our lives, and who is to say that the destination matters more than the journey?

A number of respected folk artists have fantasized a better world through their paintings, and we are the richer for their imaginings. Edward Hicks (1780–1849) was racked by theological uncertainties and criticized by fellow Quakers for his personal interpretations of scripture; today, his idealized depictions of a "Peaceable Kingdom" where lions lie down with lambs are among America's best-loved symbols of harmony. Likewise, contemporary collectors vie for the gaily painted views Charles C. Hofmann (ca. 1820–1882) created. One would hardly guess that Hofmann's sunlit representations of neat, tidy building complexes show the very almshouses that sheltered him through his bleak last years of indigence, alcoholism, vagrancy, and homelessness. Some surmise that Hofmann was driven to paint life not as it was but as he wished it to be. Fantasy and idealization have their place in giving shape to aspirations and unrealized dreams and, by so doing, often help make those dreams reality. In the direst of straits, fantasizing may enable us to hope, which can improve the quality of life and even prolong it. The middle years of O'Kelley's life were grim ones, filled with impoverishment, loneliness, and menial work. One

author calls them O'Kelley's "silent times"—and suggests that their very burdensomeness prompted O'Kelley to keep her childhood and its memories of a "kinder gentler time . . . imprinted on her soul."[9]

Critics tend to neglect the historical value of O'Kelley's paintings because of their fantasy elements and because their imagery is often subordinated to aesthetic concerns. For instance, it is indeed doubtful that buildings in early twentieth-century rural Georgia were as brightly and diversely colored, as symmetrically, evenly, and closely spaced, and as pristine and well kept as O'Kelley portrays them. Yet many aspects of a swiftly disappearing lifestyle are painstakingly described in her works.

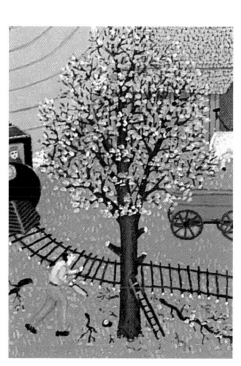

The "Moving" series includes grape arbors, rabbit hutches, barns, woodsheds, and livestock pens and depicts such daily rural chores as tree pruning, cotton picking, seed planting, contour plowing, and wood gathering, but generally these structures and activities play subsidiary roles in compositions that focus on the family's travel to and fro. The majority of these pictures are set in the city, and paintings outside the "Moving" series more explicitly document the agricultural pursuits that must have been part of the day-to-day existence of the real-life O'Kelley family and others like it. Hog killing, chicken plucking, sauerkraut making, quilt airing, cotton picking and ginning, butter churning, shoe repairing, rat killing, possum hunting, horseshoeing, livestock feeding, cider making, beehiving, plowing, threshing, fishing, and vetting the new mule: all these are described in detail in what are, perhaps, O'Kelley's best-known paintings. As we move into the twenty-first century, diminishing numbers of people can recall firsthand accounts of such once ordinary preoccupations. The preponderance of these subjects in O'Kelley's output attests to their prominence in the seasonal calendar of the typical southern farm family. Even if stylized, their minute pictorial details convince one that O'Kelley participated in such activities or observed them closely.

The artist's paintings also vividly recapture many of the religious and social events common to her growing-up years: all-day church meetings, Sunday school picnics, baptizings, "pound" suppers,[10] watermelon feasts,

visits to the general store, weekly and special holiday family gatherings, porch raisings, and yard sales. Glorious idle childhood pursuits like blindman's buff, reading the newspaper comic strips, playing under the porch, and tag in the front yard twilight are also fondly featured in O'Kelley's pictures. The "Moving" series includes beguiling glimpses of skinny-dipping (pl. 2) and camping under the stars (pl. 5). Although the latter is a necessity and not a lark in the story, the occasion is clearly delightful from O'Kelley's childhood perspective.

"Moving" primarily illustrates a country girl's astonishment and delight at life in a bustling city, reactions that the artist may have conjectured—or experienced on visits—in her youth. Because most of O'Kelley's paintings so heavily emphasize the joys of rural life, one might imagine the artist reveled in them from birth. But she only began painting late in life, when age had given her some perspective. As a child, she sometimes seems to have yearned for the "greener grass on the other side" and to have dreamed of escaping farm life's incessant grind of taxing manual labor. In her own words: "I used to think we had a hard time and everybody in the city had it made, but now I know we had a good life."[11] The dazzling array and exotic nature of the goods to be had in the city also attracted her; despite the farm's self-sufficiency, she admits that "we children liked the store-bought stuff, just the same. Bought apples smelled different from ours."[12]

Time and events can be compressed in the "Moving" pictures; historically and chronologically, some details such as movies and gas-powered vehicles and an incredible array of skyscrapers must have postdated the real-life O'Kelley's youngest years. But they may have left the older O'Kelley as awestruck as any child, and it is her emotional reaction that is believable. In the urban environment, the numbers and varieties of goods available clearly impress the youngster and are documented by a multitude of vendors' signs, symbols, and storefront samples. The spacing and heights of buildings, swarming pedestrians, and streetcars also catch her eye.

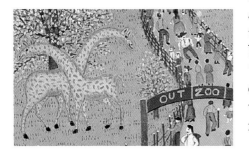

The series further introduces the child narrator to such intriguing—and sometimes bewildering—features of urban life as a hospital (she has always been "doctored" at home), an immense regional school (she was taught in a three-room variety),[13] a zoo (she knows such animals only from books), the cinema (where a movie about farm life makes her homesick), "underground" shops (where watermelon is available but, frustratingly, only for cash), and a restaurant (where the novelty of ordering "anything we wanted" barely counterbalances the discovery that the food "wasn't nearly as good as Mama's").[14]

Social historians may note other vanishing aspects of life in O'Kelley's paintings. Statistics confirm that large numbers of offspring are less common than they once were in America; mobile, transient lifestyles increasingly scatter us geographically and in some cases weaken the emotional bonds of blood kin; nuclear families seem a dying breed; and a contemporary Thanksgiving dinner is as apt to be Chinese take-out as turkey with all the trimmings. In contrast, the O'Kelley paintings emphasize the close-knit bonds of her immediate family of parents and eight children, while occasional pictures allude to an extended network of aunts, uncles, and cousins.[15] Interior views of the O'Kelley home show walls hung floor to ceiling with portraits of loved ones, including farm animals and pets. It is obvious that such relations sustained the artist in real life and provide the basis for many of the happy memories she recalls in paint. Similarly, the O'Kelley family sticks to traditional holiday fare in her pictures, as they presumably did in actuality. (In the "Moving" series, *Thanksgiving* features turkey, apple and pecan pies, and pumpkin cake). Tradition and ritual play strong roles in the O'Kelley world, and one concludes that they are used to reinforce the stability of family relationships. Regular family pilgrimages to the O'Kelley cemetery plot are one example; simple, seemingly spontaneous events like cutting up a watermelon can also assume the status of ritual in the artist's works. In a like manner, rat killing sessions recur as faithfully as the seasons and are documented as gleeful family gatherings; pulling together for the common good gives the children an excuse to romp and scramble all over the barn.

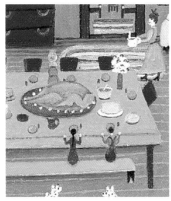

Nevertheless, it is the aesthetic aspects of O'Kelley's work that attract us initially and that may linger longest in viewers' memories. Vibrant, saturated colors beckon from every canvas, and complementary hues often heighten one another. Truth may bow to Art, as in gold clouds and purple barns. But what patient could fail to heal in a bright pink hospital with jade-green trim? Modeling is kept to a minimum so that the richness of O'Kelley's palette is uncompromised.

Pattern and rhythm are other consistently compelling features of her paintings. The repetition of the soft shapes of hillsides and mountaintops suggests that they extend into infinity, and their gently swelling forms are usually emphasized by contour plowing lanes, encircling paths, or feathery, carefully spaced trees. O'Kelley's city views provide ample opportunity for the expression of pattern and rhythm as well. Building facades and paving stones form designs that draw the eye as forcefully as the swatches of a well-planned patchwork quilt.

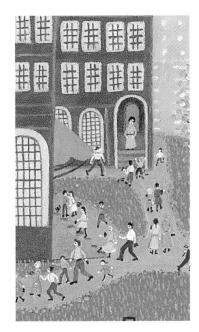

Symmetry is often a key organizing factor in O'Kelley's compositions and is illustrated in the "Moving" series in, for example, *Moving* (pl. 1), *Planting the Fields* (pl. 2), *Eating Out* (pl. 11), *On the Roof* (pl. 13), *The Rainbow Train* (pl. 14), *Movie* (pl. 16), and *Cold Wind* (pl. 18). Even when major compositional elements are asymmetrically arranged, details may be carefully set down in mirror images such as the trees and bushes in front of the off-center building in *School House* (pl. 15). Such precision and clarity gratify our human sense of orderliness and are augmented by crisp outlines and carefully spaced and separated motifs.[16] Each element has its special place in O'Kelley's works, and together they fill up her canvases. Like nature, she abhors a vacuum, so even a simple still life may stretch and grow until blossoms cover the farthest corners of her picture plane.[17]

This is fortuitous for the viewer, for O'Kelley's sense of design is unerring. Plates dot tables and chairs fan out around them in a design that echoes the floral pattern on the ceiling in *Eating Out* (pl. 11). The result is as appealing for its abstract qualities as for its narrative content. Flattened perspectives accommodate O'Kelley's incredible richness of detail and

enable us to view city streets and mountain roads at a glance. The distant mountains recede in atmospheric perspective in *New Mountain Road* (pl. 4), and the skyline in *On the Roof* (pl. 13) uses a simple variant of this technique to suggest that the brightly lit, fairyland city extends endlessly.

The facts of the artist's life are integral to her works, as her paintings' strong, recurring autobiographical aspects suggest. Emily Mattie Lou O'Kelley was born March 30, 1908, the seventh of the eight children of Augustus Franklin O'Kelley and his wife, Mary Bell Cox O'Kelley.[18] Her father, "a proud and frugal Irishman,"[19] labored as a tenant farmer before saving enough money to buy his own land,[20] eventually acquiring a 129-acre holding near Maysville, Georgia,[21] that the artist lovingly documented in paint.[22] O'Kelley's mother was "an honest Texas girl" who evidently loved rural life.[23] Cotton was the cash crop on the O'Kelley farm, and many of O'Kelley's paintings reveal details of cotton planting and processing. In addition, hay and corn were grown for the livestock, along with vegetables and fruits for family consumption.

O'Kelley's paintings and brief writings give us numerous glimpses of her impressions of her parents' characters. *Papa's Car* suggests the man sometimes threw frugality to the winds and indulged a streak of wild impetuosity: when crop sales fared particularly well one year, he brought home an automobile, amazing his family as much by the car as by his inability to drive it.[24] Franklin O'Kelley could rise at 4:00 A.M. to feed his mules in the belief that they needed time to digest their food before a day's work.[25] Yet the rigors of such a farming schedule still left him enough energy to play "Bear in the Hall" with his children on long winter nights.[26]

When her youngsters became feverish with malaria, Mary O'Kelley made them pallets on the porch, covered them with quilts, and dosed them with "Grove's Chill Tonic" (castor oil was her remedy of choice for green apple stomachaches),[27] and her memorable meals have been honored in her daughter's paints and words.[28] On a sterner note, she seems to have been the disciplinarian in the family. In *Circus!*, "Mama" not only whips the children for ignoring chores but also makes them whip one another.[29]

O'Kelley documented her own birth in a 1981 painting, showing her mother in bed with the new baby while family and friends bustle around the room, adding the notation that it was the first time her mother had had a doctor.[30] Her older siblings—Willie, Lillie, Gertrude, Ruth, Tom, and Ben—appear in many of her paintings. *Papa's Workshop* shows the three boys busy shoeing mules and conditioning various farm tools.[31] O'Kelley's sister Gertrude, described as "the puny one," was spared field work, instead keeping chickens, ducks, and turkeys at home, where one of her charges regularly tormented the young O'Kelley, as in *Sister Gertrude's Old Gobbler*.[32] Lillie yearned for city life and left home to take a business course in Atlanta, returning for holiday visits "a perfumed genteel lady."[33]

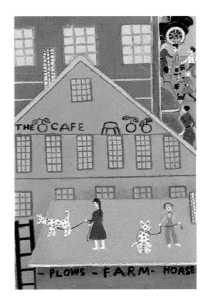

John Tyler ("Johnnie") O'Kelley was the artist's only younger sibling. Born three years after her, he was described as her "playmate and best friend,"[34] and the two appear inseparable in many paintings, including all of the city adventures in the "Moving" series. Johnnie's death at age twelve from a fall off a pony must have been a shocking loss to O'Kelley.[35] It came at a particularly turbulent time in her life. Adolescent awkwardness discomfited her naturally bashful and retiring nature, and a five-foot, ten-inch frame only aggravated her self-consciousness. In 1983, on her seventy-fifth birthday, O'Kelley completed a poignant recollection of that loneliness and ill ease; in *Mattie Lou in Her Beau-Catching Outfit*, a group of festive party-goers seems oblivious to the teenage O'Kelley, who stands apart and alone in a brand new hat and dress, thwarting all of her mother's efforts to introduce her to eligible young men. No wonder O'Kelley loved Louisa May Alcott's *Little Women*;[36] she must have seen herself in the character of the painfully shy Beth.

Mary O'Kelley's "eager plans for [her daughter's] romance never struck flint,"[37] and as the artist's siblings grew up, married, and moved away one by one, O'Kelley remained at home and helped maintain the family farm. Her father died in 1943,[38] whereupon she and her mother moved into a small house in nearby Maysville; there, O'Kelley cared for her aging remaining parent for another twenty years. To make ends meet, she em-

barked on a series of relatively short-lived millwork positions and odd jobs, all of which she thoroughly hated. Due to her ninth grade education and lack of salable skills and society's restrictions on the opportunities available to women in general, O'Kelley's choices were limited.

When her mother died, O'Kelley faced the prospect of living alone for the first time. She moved into a modest one-room cabin next to a Maysville factory. There, in 1967,[39] she began dabbling with artwork, first drawing with crayons and then ordering paints and canvases from Sears and Roebuck, teaching herself and simply using her materials to pass the time because she was "lonesome."[40] In poor health and unable to work,[41] she occasionally bartered or sold a painting for food or other necessities, such as furniture. In retrospect, O'Kelley says "I should have been on welfare, but I had too much pride."[42]

In these early years, O'Kelley's paintings sometimes sold for as little as $1.00,[43] but she was encouraged by the fact that they sold at all, and eventually she turned her full attention to painting. A newspaper article about a show of Georgia artists' work being sponsored by the High Museum in Atlanta induced her to board a bus and take some of her paintings there. The director of the museum liked one of the canvases enough to buy it,[44] and other pieces were placed in the museum's shop for sale to the public.

Dr. Robert Bishop first saw the High Museum's painting and those for sale in its shop in 1975. Then the director of publications at the Henry Ford Museum and Greenfield Village in Dearborn, Michigan, and later director of the Museum of American Folk Art in New York City, Bishop had studied and enjoyed the works of a number of self-taught artists and in many cases actively promoted their discovery and appreciation. Bishop's enthusiasm for O'Kelley's work was immediate. Largely through his efforts, word of her work began to spread. In 1976, she was represented in the High Museum's critical show, "Missing Pieces: Georgia Folk Art, 1770–1976," and that same year she was awarded the Governor's Award in the Arts for the state of Georgia. Demands for her pictures increased, and she found herself becoming something of a celebrity.

Greater financial independence and a rejuvenated sense of self-confidence coupled with O'Kelley's natural curiosity prompted her to try living in New York City in 1977, but the harsh climate of the North was too much for her. She then tried living in West Palm Beach, Florida, but decided it was too hot, and by the late 1970s she had resettled in Georgia, in Decatur. Through all these moves she continued painting, sometimes capturing the scenes around her,[45] sometimes recapturing her Georgia childhood.

O'Kelley's artistic nature has been so thoroughly expressed through painting that her yen to write is often overlooked. She fell in love with books as a shy, withdrawn teenager,[46] and reading likely stimulated her naturally vivid imagination. Initially, she aspired to write fiction for a living. As late as 1979, she claimed, "I just painted for fun, some I gave away, some sold, some traded. I never expected people to like them. They were for my own pleasure. I would rather write, if it would get published. I am also working on a novel, for fun, I suppose. Three have failed."[47]

In 1982, O'Kelley illustrated Ruth Yaffe Radin's children's book, *A Winter Place*. The volume's warm reception may have convinced O'Kelley that a simple text with emphasis on her paintings could succeed, and in 1983 she came out with her own "autobiography in paintings" called *From the Hills of Georgia*, following it by a larger book of similar format, *Mattie Lou O'Kelley: Folk Artist*, in 1989. She was both author and illustrator of the children's book called *Circus!* (1986), which also preceded *Moving to Town* (1991).

Despite these forays into children's writing and the world of publishing, O'Kelley's painting has continually brought her the widest renown. New York City dealers handle sales of her works,[48] one of her paintings was featured on the cover of *Life* in June 1980,[49] and through the 1980s, newspapers and magazines increasingly wrote about her and her work. O'Kelley's first solo exhibition was a display of the "Moving" series at the High Museum's Georgia-Pacific Center in 1990. Today, her works are regularly shown in museums and galleries and are included in the permanent collections of several major institutions.

Although O'Kelley seems to have enjoyed many aspects of her late-won renown, her private nature and her dedication to her art have prevented her from embracing fame and immersing herself in it.[50] Through her latter years, she has continued to maintain the relatively solitary existence to which she has long been accustomed. O'Kelley painted steadily until quite recently, but friends fear that a watercolor of a farm scene done in late 1993 may be her last work and that deteriorating health may have finally forced this remarkable woman to put down her brushes for good.[51] As of this writing, O'Kelley is still living in Georgia.

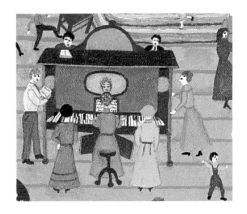

Notes

1. These features are illustrated in O'Kelley's "Moving" series in, respectively, *Santa Claus* (pl. 19), *The Rainbow Train* (pl. 14), and *On the Roof* (pl. 13). The latter depicts a huge roaring lion atop a city sign reading "Lion's Club."

2. *Moving to Town* was published in 1991 by Little, Brown and Co., Boston.

 As of this writing, T. Marshall Hahn, Jr., owns the twenty-four "Moving" paintings. Inspired by several O'Kelley canvases he had seen at the High Museum in Atlanta, Hahn began looking for an example he might buy. After a fruitless search, in 1987 he finally tracked down O'Kelley herself.

 Characteristically unenthusiastic about having her work interrupted, O'Kelley told Hahn she had nothing for sale. Noting the three "Moving" paintings she had finished at that point (and a fourth in progress), Hahn inquired about them, but O'Kelley firmly told him she would not break up the projected set of twenty-four. Undeterred, Hahn agreed to purchase the entire series.

3. Barbara Archer, curator of a 1990 exhibition of the "Moving" paintings, aptly calls them "a mixture of reality and childhood memories and fantasies that she creates in her head." Steve Murray, "The Past Is Present: Mattie Lou O'Kelley 'Moving' forward as she recalls Ga. roots in her folk art," *Atlanta Journal and Constitution*, Jan. 28, 1990, pp. N1, N10.

 O'Kelley has also produced paintings that fall into a far clearer, less ambiguous category of fantasy, although these are relatively rare. An example is her *Ship of Complacency*, no. 109 in *America Expresses Herself: 18th, 19th & 20th Century Folk Art from the Herbert W. Hemphill, Jr., Collection*, a small catalog that accompanied a special exhibit at the Children's Museum, Indianapolis, Ind., Oct. 2, 1976–Mar. 13, 1977; Hemphill's *Ship of Complacency* is illustrated therein as the centerfold. T. Marshall Hahn, Jr., owns a related picture titled *Ship of Complacency No. 2*.

4. No accurate count of O'Kelley's paintings has ever been taken. It would be difficult to do so because many of her works were given away or traded or sold for negligible amounts in the 1960s and 1970s.

 Farm life is the dominant theme of the vast majority of O'Kelley's recorded paintings. Still life depictions form a smaller category among her works. Examples have been published in Anna Wadsworth, *Missing Pieces: Georgia Folk Art, 1770–1976* (Atlanta, 1976), and Mattie Lou O'Kelley, *Mattie Lou O'Kelley, Folk Artist* (Boston, 1989). An occasional animal portrait has also been published. Some appear in O'Kelley, *Mattie Lou O'Kelley*.

 Portraits of people, including self-portraits, represent a little-known aspect of her work. A 1973 self-portrait appears *ibid.*, p. 76; another, dated 1992, is owned by T. Marshall Hahn, Jr., and serves as the frontispiece of this catalog. See also n. 3 regarding O'Kelley's full-blown fantasy paintings which are, perhaps, her least-publicized works.

5. Many scholars, including John Michael Vlach, limit the term "memory painters" to those who record pleasant recollections of domestic or small-town life. John

Michael Vlach, *Plain Painters: Making Sense of American Folk Art* (Washington, D. C., 1988), p. 169. In general, other descriptions apply to those who fantasize more overtly, focus on socio-historical rather than personal events, or create from a sense of personal angst or social malaise.

Vlach's narrow definition of a "memory painter" suits O'Kelley better than most other labels commonly applied to modern-day self-taught artists. Nevertheless, a broader, looser definition of "memory painting" seems more appropriate to the purposes of this essay, which attempts to deal with additional strains in the artist's work and to define her style more clearly. (Vlach admits that his term "memory painting" describes content but does not address style.)

6. An exception, *Mattie Lou in Her Beau-Catching Outfit*, is discussed on p. 9. It is illustrated in Mattie Lou O'Kelley, *From the Hills of Georgia: An Autobiography in Paintings* (Boston, 1983), p. 31.

7. *Boogers* shows O'Kelley and her brother on a nighttime errand beset by "boogers," and *Whipping in the Backyard* shows what they received for their negligence. These pictures are illustrated in Mattie Lou O'Kelley, *Circus!* (Boston, 1986), pp. 3–4 and 7, respectively.

8. About her distortions toward the positive, O'Kelley states, simply and logically enough, "I have good thoughts—that's why I have good paintings." O'Kelley, *Mattie Lou O'Kelley*, p. 81.

9. Jane D. Robertson, "Mattie Lou O'Kelley: A Nostalgic Glance at the Past" (master's thesis, Hollins College, 1989), p. 8.

10. A pound supper is a meal to which each guest brings a pound of food, as explained in O'Kelley, *From the Hills of Georgia*, p. 13.

11. Quoted in Mark Childress, "Painting Memories of Georgia," *Southern Living* (Aug. 1983), p. 89. O'Kelley told another writer, "It was an awful hard life, but as I look back we had a lot of fun." Joyce Leviton, "From Memories of Country Life Mattie Lou O'Kelley Makes Magic Landscapes," *People* (Nov. 12, 1984), p. 73.

12. Childress, "Painting Memories of Georgia," p. 88.

13. O'Kelley, *From the Hills of Georgia*, p. 23.

14. O'Kelley, *Moving to Town*, p. 11.

15. See, for instance, *Family Gathering* and *Thanksgiving, ibid.*, pp. 21 and 32, respectively.

16. A distinctive "dot" style much like pointillism was often practiced by O'Kelley in the 1970s and early 1980s, especially in watercolors. Published examples are *Checking Out the New Mule, Reading the Newspaper*, and *The Garden of Eden* in O'Kelley, *Mattie Lou O'Kelley*, pp. 9 and 19. Elements of this style survive in her later and more sharply defined oils and acrylics, usually as isolated motifs such as tree leaves and window curtains.

17. Good examples are her morning glory pictures, e.g., *Morning Glories, Bowl of Morning Glories*, and *Color Morning Glories*, shown *ibid.*, on pp. 25 and 84, and *Morning Glories*, shown as no. 22 on p. 50 in Wadsworth, *Missing Pieces*. Her self-

portrait called *Mattie in the Morning Glories* also shows her space filling use of these flowers. It is owned by T. Marshall Hahn, Jr.

18. O'Kelley's full name, those of her parents, and her birth date are given in O'Kelley, *From the Hills of Georgia*, pp. 4–5. "Emily" was her mother's sister's name, "Mattie" was her maternal grandmother's name, and "Lou" was the name of a neighborhood friend of her mother's. O'Kelley, *Mattie Lou O'Kelley*, p. 80.

19. O'Kelley, *From the Hills of Georgia*, p. 19.

20. O'Kelley, *Mattie Lou O'Kelley*, p. 81.

21. Murray, "Past Is Present," p. N10.

22. The painting, *My Parents' Farm*, is shown in O'Kelley, *Mattie Lou O'Kelley*, p. 16.

23. The quote is from O'Kelley's poem called "Autobiography," where she also states that her mother "loved the terraced land." *Ibid.*, p. 77. In O'Kelley's semi-fictional *Moving to Town*, p. 2, "Mama" wistfully remarks "That plowed field sure smells good" as the family leave their country home for life in the city.

24. O'Kelley, *From the Hills of Georgia*, p. 19.

25. See *Papa Feeding the Mules at Four A.M., ibid.*, p. 22.

26. *Ibid.*, p. 8.

27. *Ibid.*, pp. 20 and 26.

28. See, for instance, *Chicken Dumplings and Cherry Pie Dinner* in O'Kelley, *Mattie Lou O'Kelley*, p. 56.

29. O'Kelley, *Circus!*, p. 7. *Circus!*, like *Moving to Town*, is a quasi-autobiographical children's book.

30. O'Kelley, *From the Hills of Georgia*, p. 5.

31. *Ibid.*, p. 12.

32. *Ibid.*, p. 7.

33. See *Lillie Catching the Train for Atlanta* and *Thanksgiving, ibid.*, pp. 28 and 32.

34. *Ibid.*, p. 31.

35. In 1979, fifty-six years after Johnnie's death, O'Kelley continued to refer to herself as the "next to the last youngest child." Linda and Bin Ramke, "Mattie Lou O'Kelley: American Folk Artist," *Georgia Review*, XXXIII (Winter, 1979), p. 807, quoting from a Sept. 30, 1979, letter of O'Kelley's. In describing Johnnie's death in a 1990 interview, O'Kelley said her father "never got over it." Alma Bowen, "Mattie Lou O'Kelley: From Morning Glories to International Fame," *Georgia Living* (Jan.–Feb. 1990), p. 5. It is evident the statement could also apply to O'Kelley herself.

36. The painting and statement both appear on p. 31 of O'Kelley, *From the Hills of Georgia*.

37. *Ibid.*, p. 31.

38. Chuck and Jan Rosenak, *Museum of American Folk Art Encyclopedia of Twentieth-Century American Folk Art and Artists* (New York, 1990), p. 228.

39. Published accounts vary widely regarding the exact date O'Kelley took up painting. Two sources say it was in 1950. Jay Johnson and William C. Ketchum, Jr., *American Folk Art of the Twentieth Century* (New York, 1983), p. 221; C. Kurt Dewhurst, Betty MacDowell, and Marsha MacDowell, *Artists in Aprons: Folk Art by American Women* (New York, 1979), p. 168.

 Wadsworth, *Missing Pieces*, p. 51, quotes O'Kelley as saying she started painting "about 1960, somewhere along in there." Other sources give the date as about *age* 60, i.e., about 1968. See Ramke, "Mattie Lou O'Kelley," p. 807, quoting from her letter of Sept. 30, 1979; Murray, "Past Is Present," p. N10; and Rosenak, *Museum of American Folk Art Encyclopedia*, p. 229. These statements suggest the possibility of year/age date confusion.

 T. Marshall Hahn, Jr., owns a crayon drawing signed by O'Kelley and dated "Sept. 1967," a drawing which he says O'Kelley identified as "her first artistic effort." Hahn to AARFAC, Sept. 28, 1994.

40. Leviton, "From Memories of Country Life," p. 75.

41. O'Kelley retired in 1968 due to illness associated with the textile industry, according to one account. Robertson, "Mattie Lou O'Kelley," p. 9.

42. Bowen, "Mattie Lou O'Kelley," p. 5.

43. Robertson, "Mattie Lou O'Kelley," p. 9, says O'Kelley's paintings sold in the early 1960s for as little as $1.50, but Childress, "Painting Memories of Georgia," p. 88, quotes O'Kelley as saying, "I painted this one girl's portrait and she paid me a dollar. One year I made $35." Bowen, "Mattie Lou O'Kelley," p. 5, also states that O'Kelley's early paintings brought as little as $1.00 apiece.

44. *Vegetable Scene*, 1968, illustrated as no. 21, p. 50, in Wadsworth, *Missing Pieces*.

45. The 1978 *Rooms*, for instance, shows the view from O'Kelley's studio apartment in New York City, and *Sassy Cat*, done the same year, portrays the regular four-legged visitor to her yard in Florida. These are illustrated in O'Kelley, *Mattie Lou O'Kelley*, pp. 65 and 17, respectively.

46. She said, "I could read all day and never miss a soul" in her Sept. 30, 1979, letter, quoted by Ramke, "Mattie Lou O'Kelley," p. 807.

47. *Ibid.*, pp. 807–808, quoting a Sept. 30, 1979, letter of O'Kelley's.

48. Jay Johnson's American Heritage Gallery in New York City was O'Kelley's exclusive agent for several years but is no longer in business.

49. Besides being featured on the magazine's cover, O'Kelley's work is illustrated and mentioned in Todd Brewster, "Fanciful Art of Plain Folk" in the same issue. *Life* (June 1980), pp. 113–122.

50. Childress, "Painting Memories of Georgia," p. 89, quotes O'Kelley as saying, "I got some neighbors around here who say, 'Why don't you come see us?' But I don't much. See, they're retired, and they don't have any hobbies. They just like to sit and talk. If I go to see them, I've took up time, and then they come back to see me. I've got too much work to do for all that."

51. The 1993 watercolor was done for T. Marshall Hahn, Jr.

MOVING

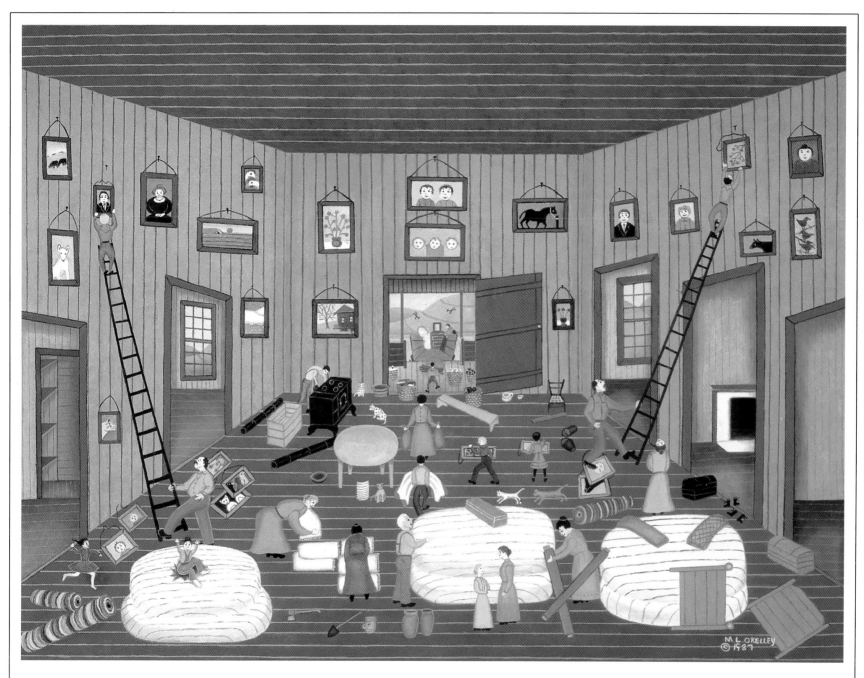

1. Moving

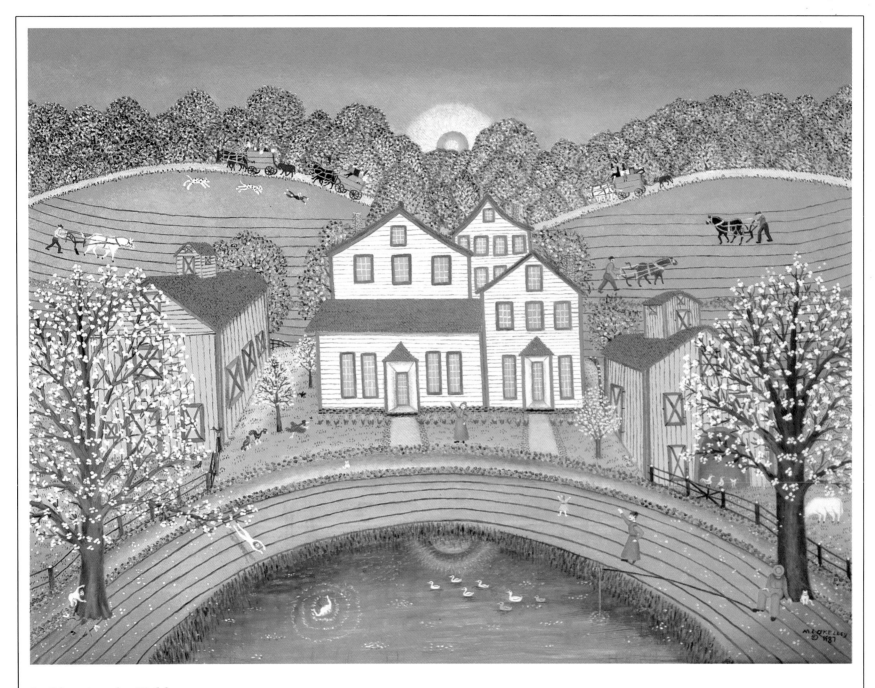

2. *Planting the Fields*

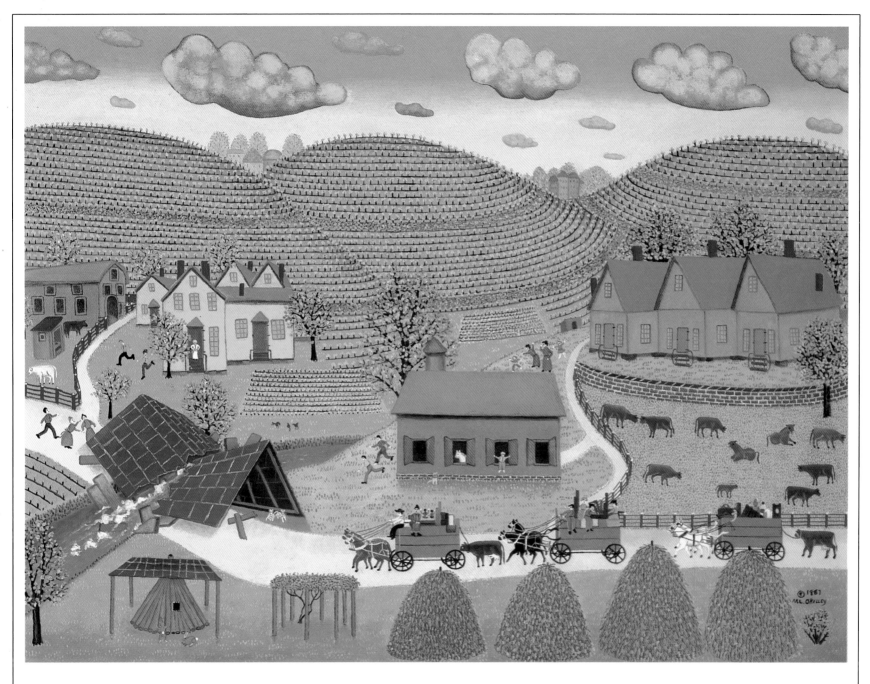

3. *Bridge Down*

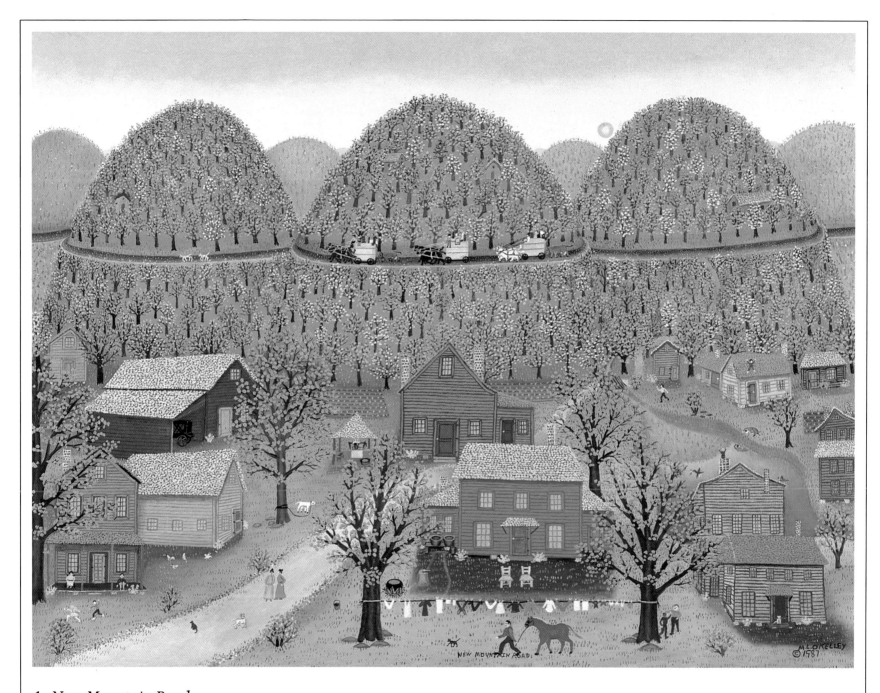

4. *New Mountain Road*

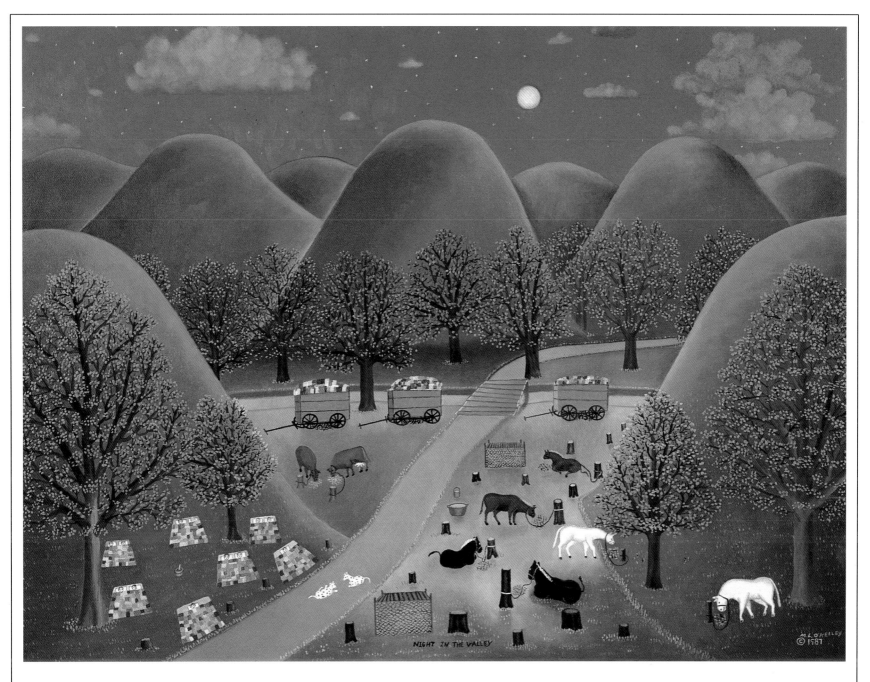

5. *Night in the Valley*

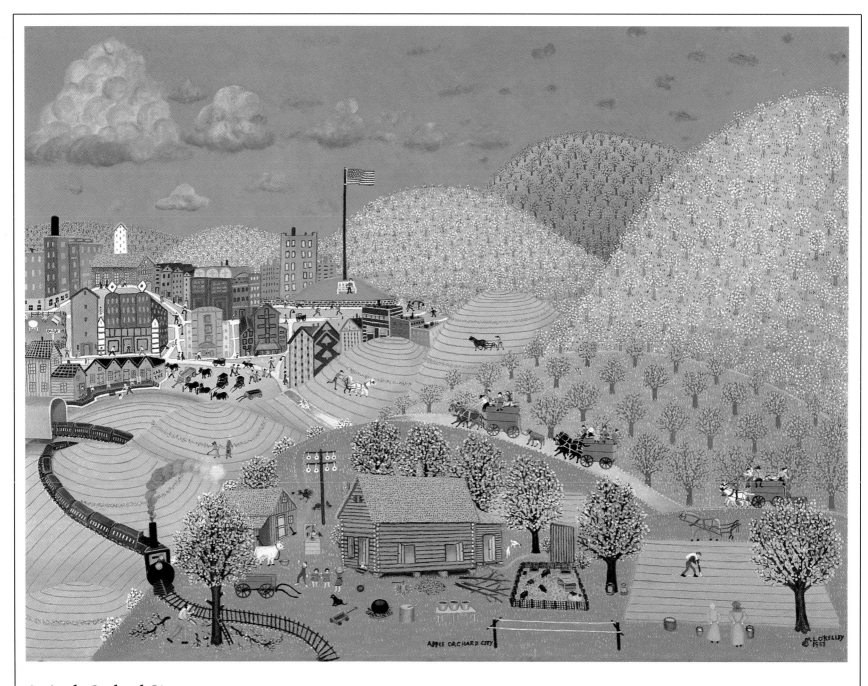

6. *Apple Orchard City*

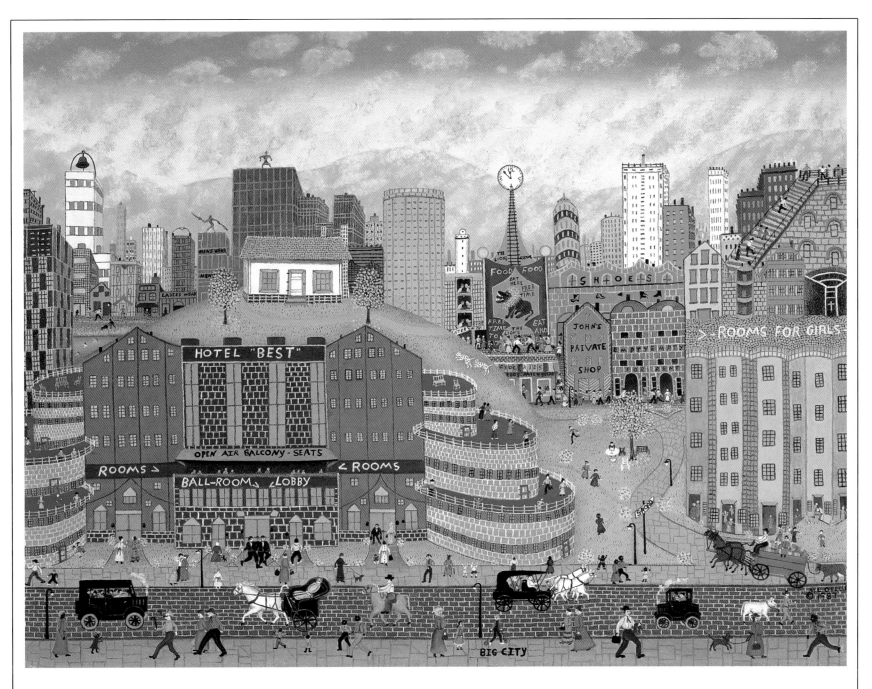

7. *Big City*

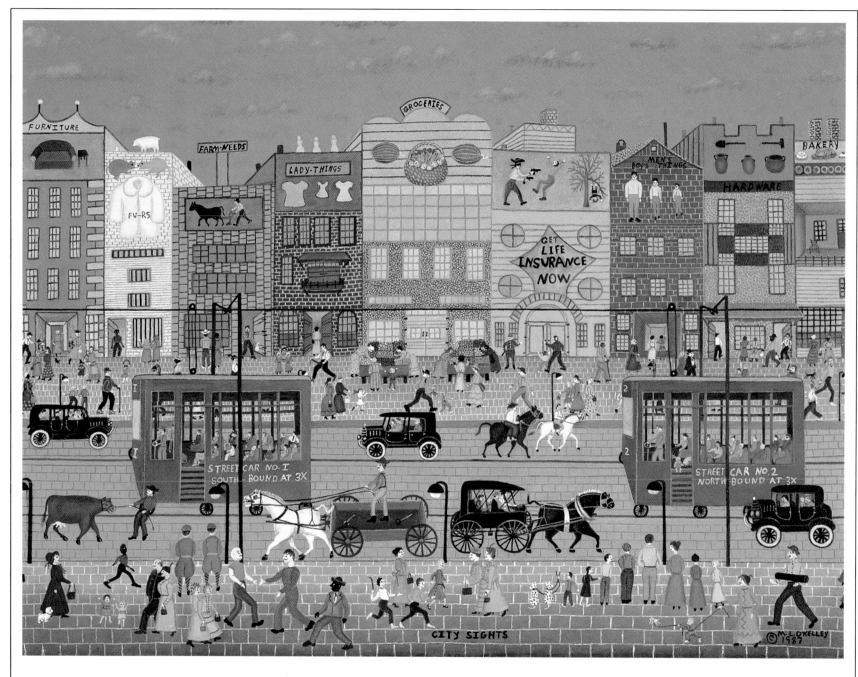

8. *City Sights*

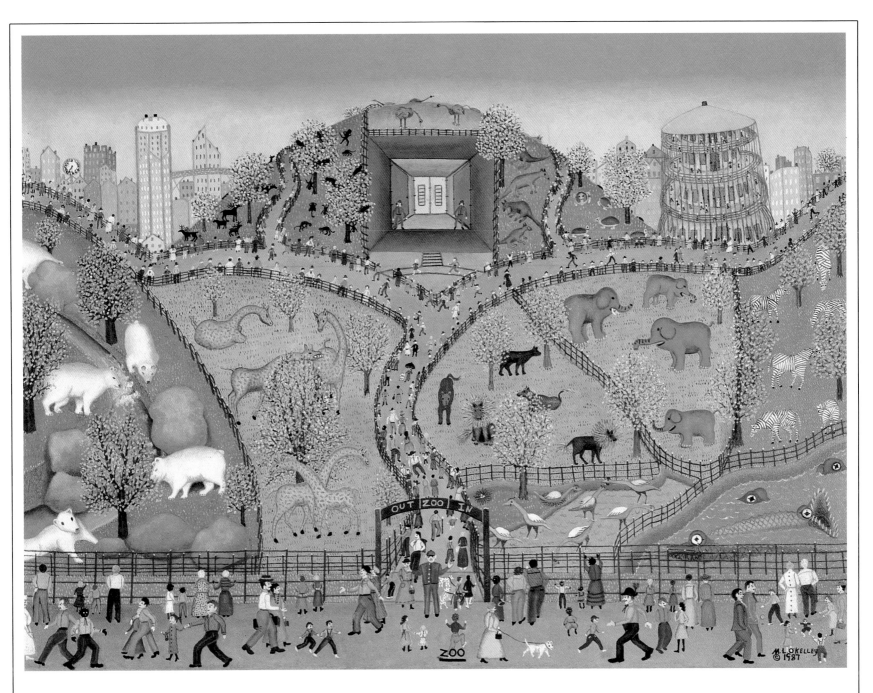

9. Zoo

27

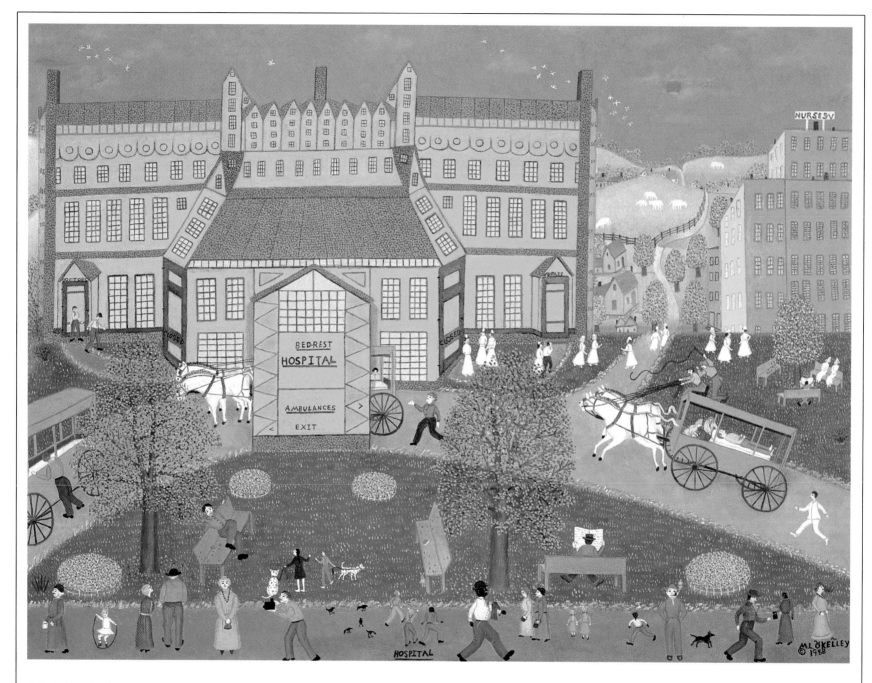

10. Hospital

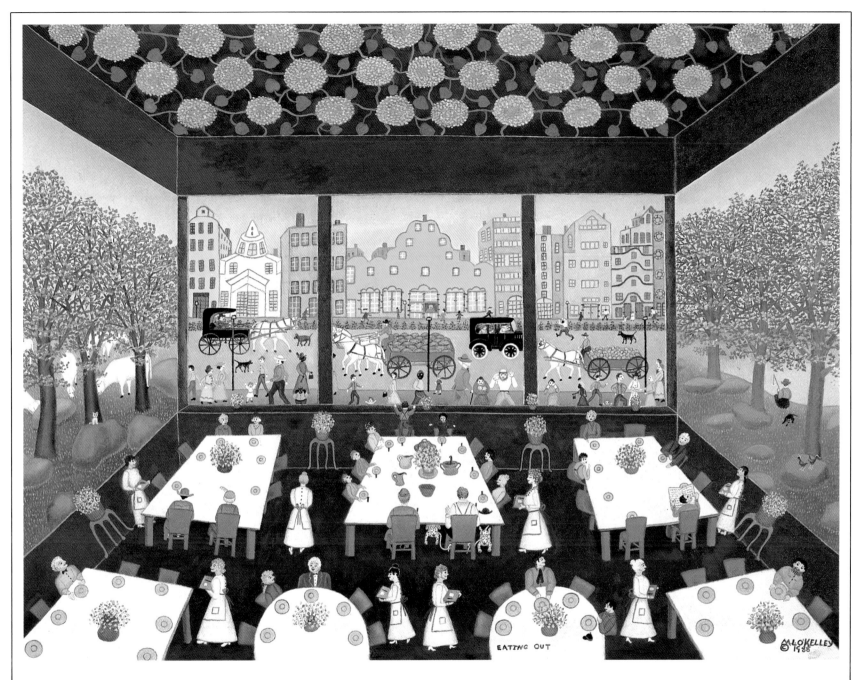

11. *Eating Out*

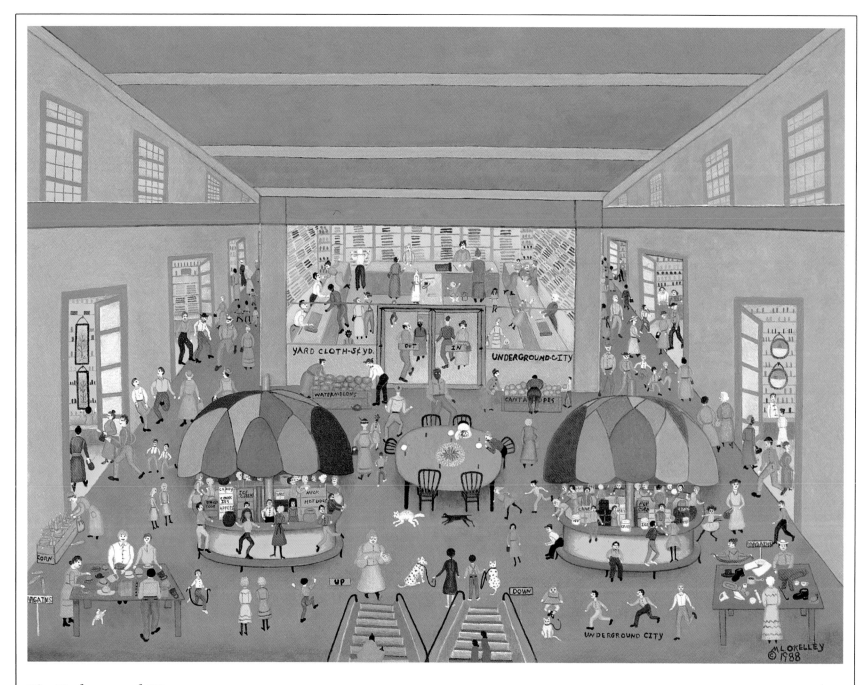

12. *Underground City*

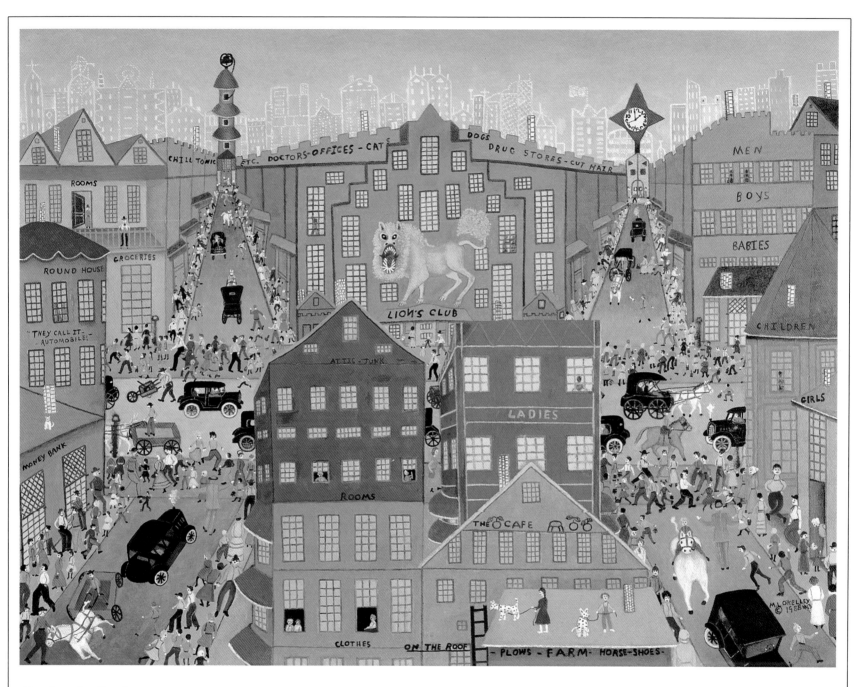

13. On the Roof

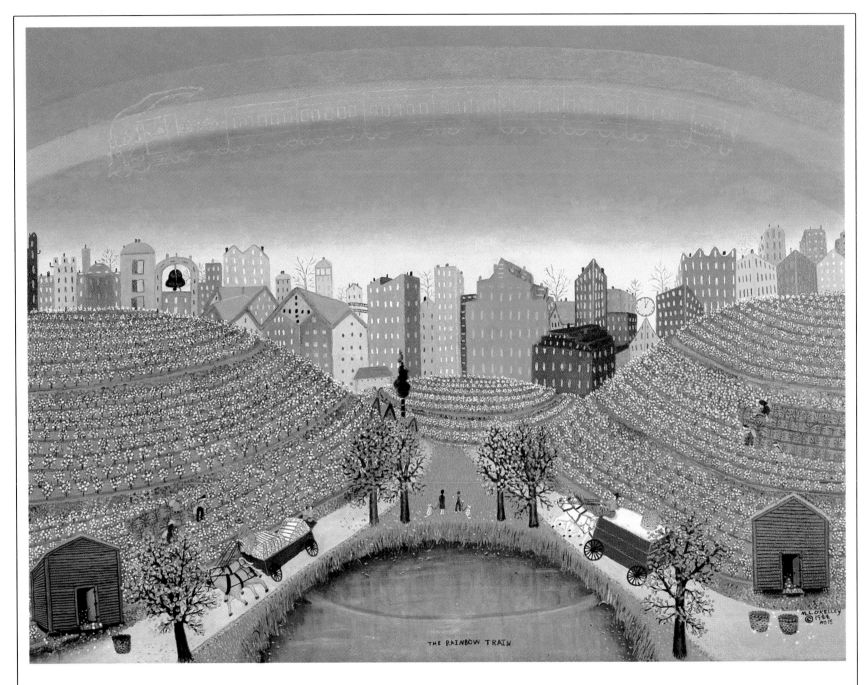

THE RAINBOW TRAIN

14. *The Rainbow Train*

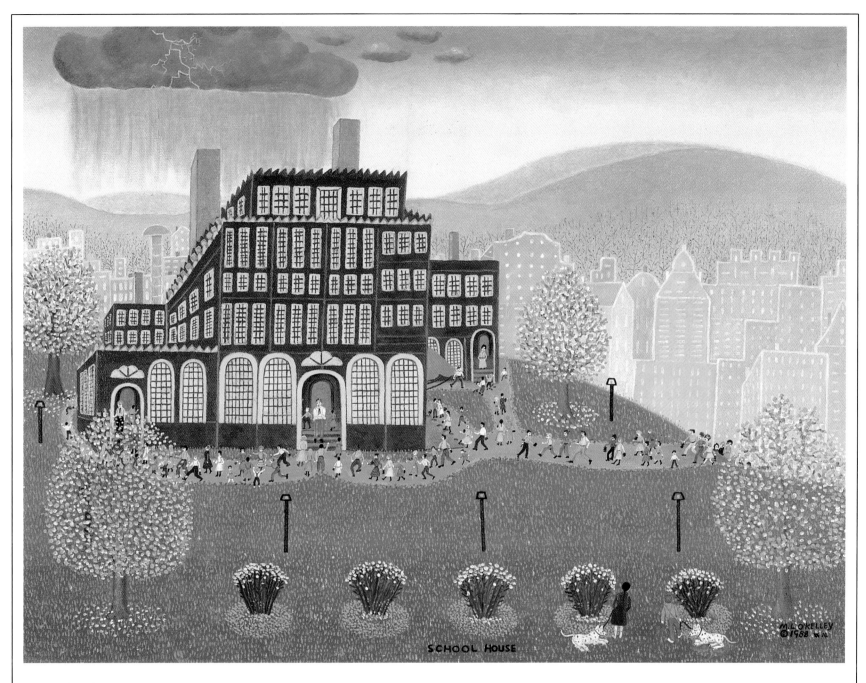

15. *School House*

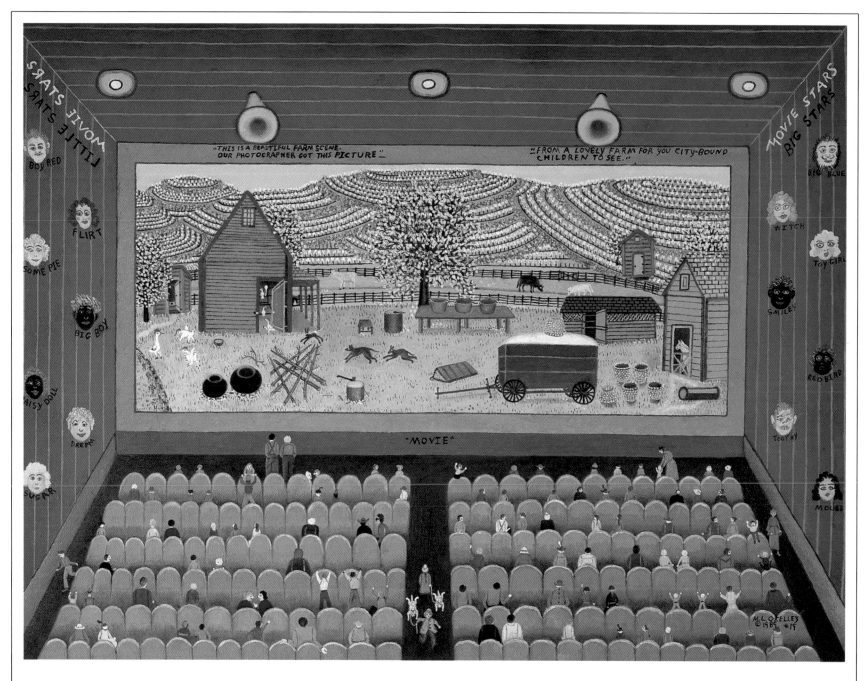

16. Movie

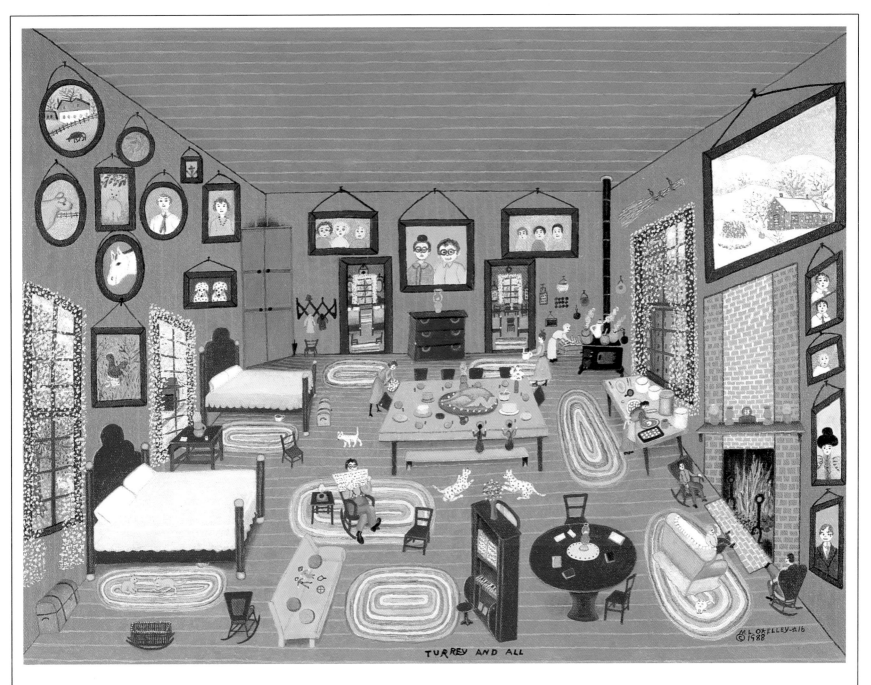

17. *Turkey and All*

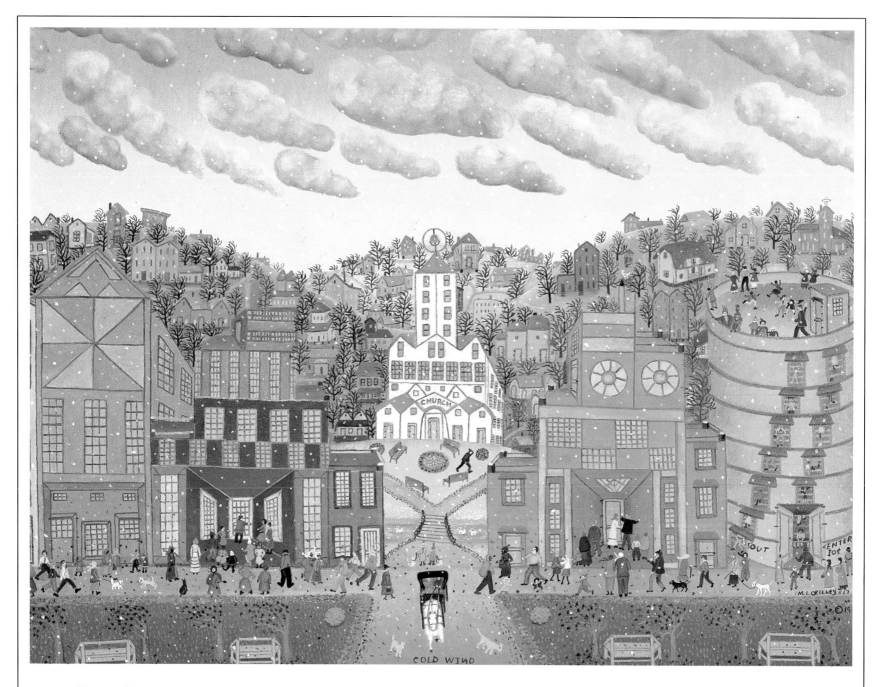

18. *Cold Wind*

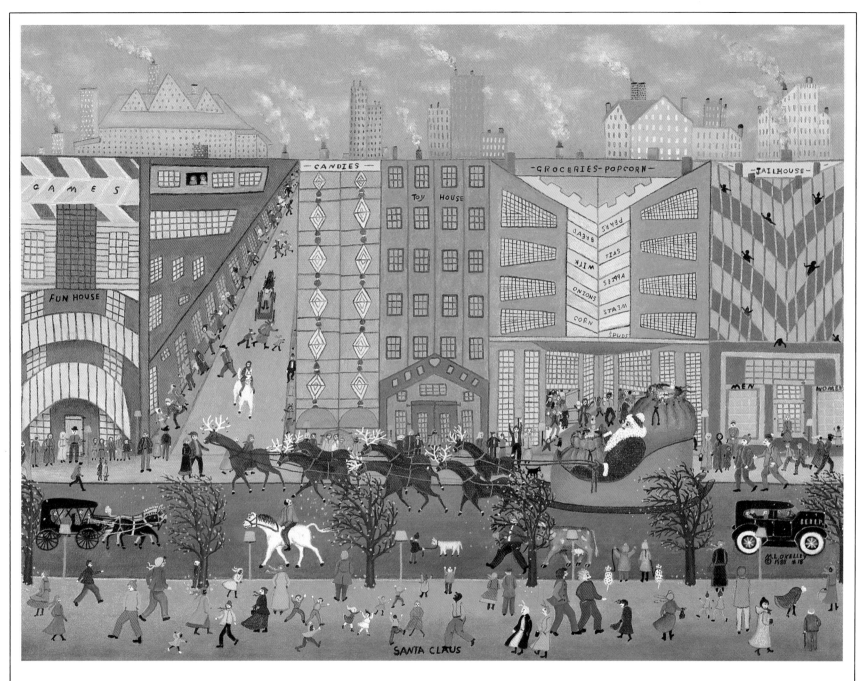

19. *Santa Claus*

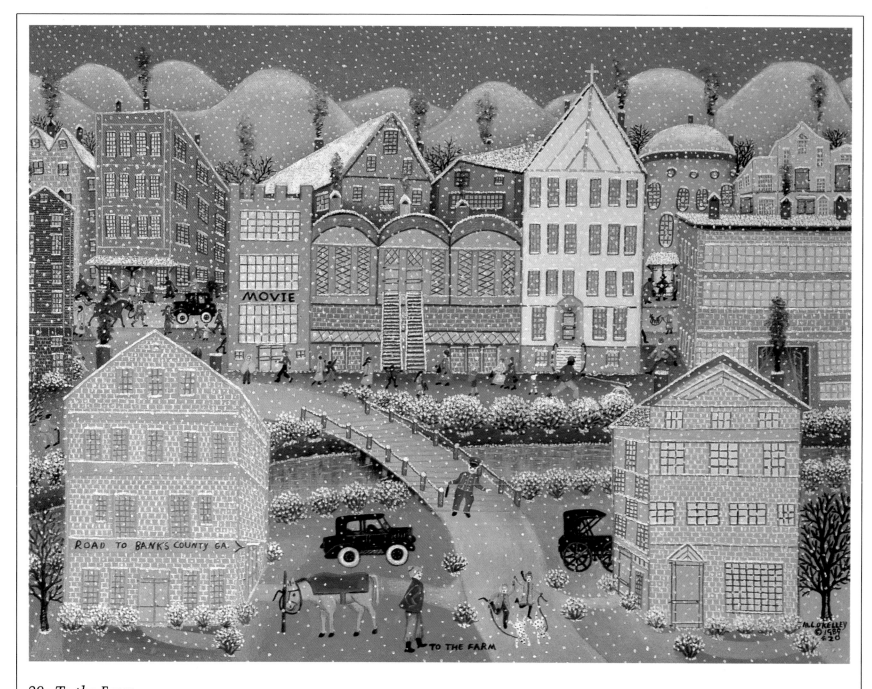

20. To the Farm

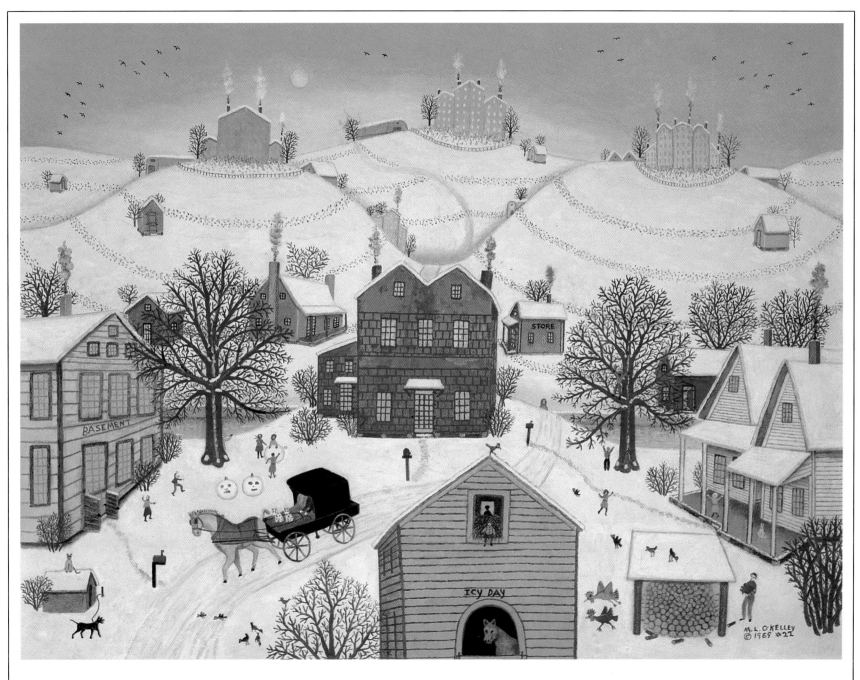

21. *Icy Day*

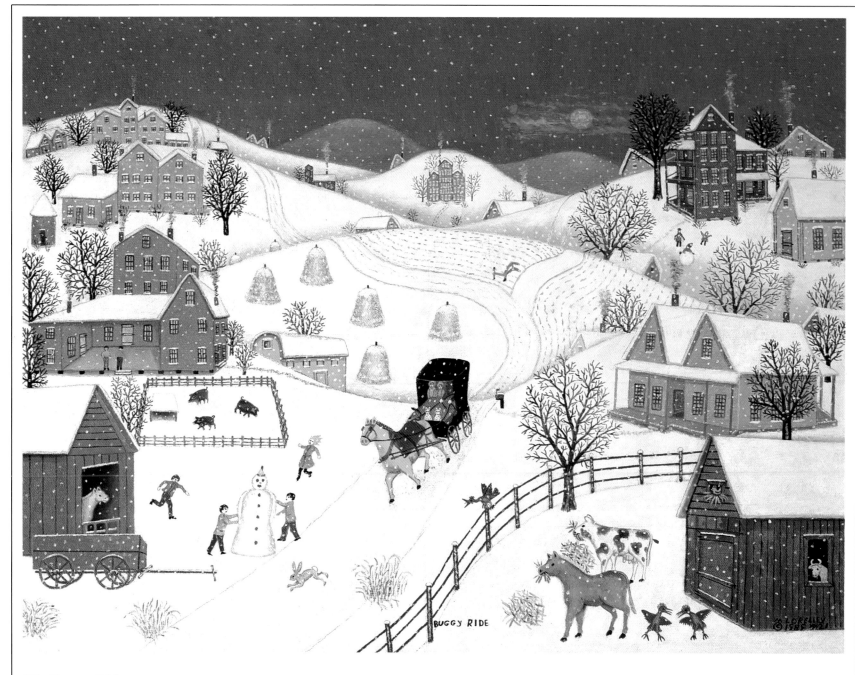

22. *Buggy Ride*

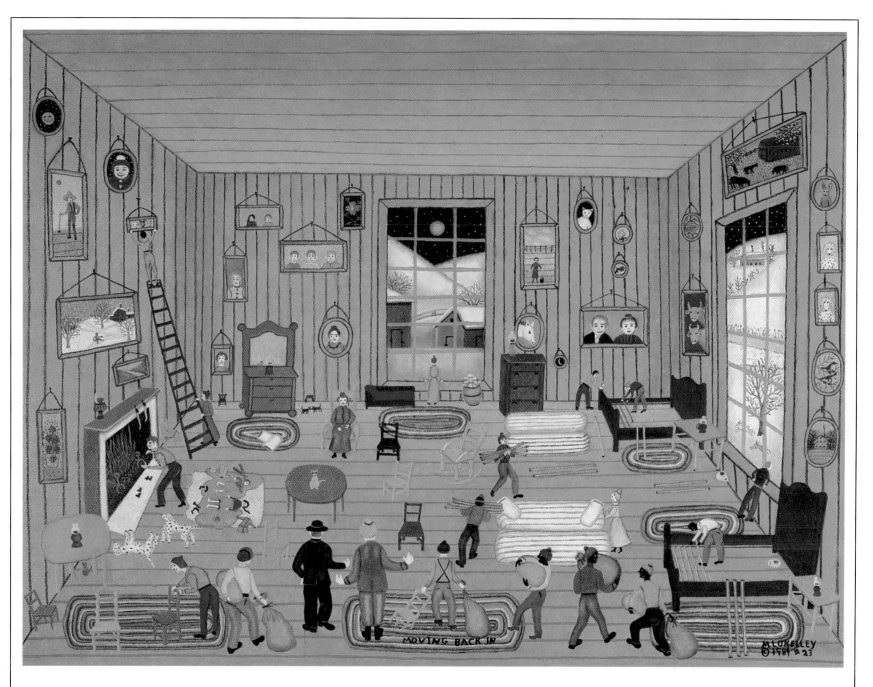

23. *Moving Back In*

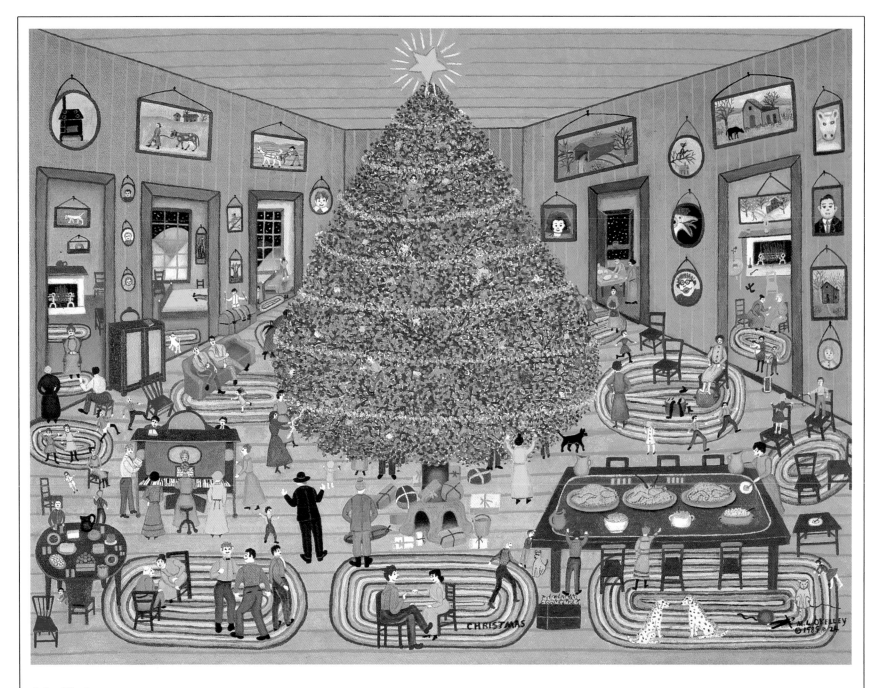

24. *Christmas*

Bibliography

America Expresses Herself: 18th, 19th & 20th Century Folk Art from the Herbert W. Hemphill, Jr., Collection. Catalog for an exhibition at the Children's Museum, Indianapolis, Indiana, October 2, 1976–March 13, 1977.

Bishop, Robert. *Folk Painters of America.* New York: E. P. Dutton, 1979.

Bishop, Robert, Susan Klein, William Secord, and Gerard C. Wertkin. *American Folk Art: Expressions of a New Spirit.* New York: Museum of American Folk Art, 1983.

Bishop, Robert, Judith Reiter Weissman, Michael McManus, and Henry Niemann. *Folk Art: Paintings, Sculpture & Country Objects.* New York: Alfred A. Knopf, 1983.

Bowen, Alma. "Mattie Lou O'Kelley: From Morning Glories to International Fame." *Georgia Living* (January–February 1990), pp. 5–6.

Brewster, Todd. "Fanciful Art of Plain Folk." *Life* (June 1980), pp. 113–122.

Childress, Mark. "Painting Memories of Georgia." *Southern Living* (August 1983), pp. 88–89.

Dewhurst, C. Kurt, Betty MacDowell, and Marsha MacDowell. *Artists in Aprons: Folk Art by American Women.* New York: E. P. Dutton in association with the Museum of American Folk Art, 1979.

Folk Art Finder (January/February/March 1986), pp. 18–19.

Goldman, Martin, and Marian Gordon Goldman, "Paints from Sears." *Working Woman* (February 1984), p. 138.

Hahn, T. Marshall, Jr. Telephone interview with Barbara Luck, AARFAC, August 10, 1994.

Hall, Julie. *Fullspectrum: Michigan Moderns/Contemporary American Folk Painting.* Detroit: Michigan Artrain, 1978, cat. nos. 2 and 3.

Johnson, Jay, and William C. Ketchum, Jr. *American Folk Art of the Twentieth Century.* New York: Rizzoli, 1983, pp. 221–224.

Leviton, Joyce. "From Memories of Country Life Mattie Lou O'Kelley Makes Magic Landscapes." *People* (November 12, 1984), pp. 73–75.

Miles, Kimberly. "Mattie Lou O'Kelley: Historical Painter." Paper presented November 10, 1992.

Murray, Steve. "The Past Is Present: Mattie Lou O'Kelley 'Moving' forward as she recalls rural Ga. roots in her folk art." *Atlanta Journal and Constitution*, January 28, 1990, pp. N1 and N10.

O'Kelley, Mattie Lou. *Circus!* Boston: Little, Brown and Co., 1986.

———. *From the Hills of Georgia: An Autobiography in Paintings*. Boston: Little, Brown and Co., 1983.

———. *Mattie Lou O'Kelley, Folk Artist*. Boston: Little, Brown and Co., 1989.

———. *Moving to Town*. Boston: Little, Brown and Co., 1991.

Radin, Ruth Yaffe. *A Winter Place*. Boston: Little, Brown and Co., 1982.

Ramke, Linda and Bin. "Mattie Lou O'Kelley: American Folk Artist." *Georgia Review*, XXXIII (Winter, 1979), pp. 806–816.

Raymond, Allen. "Folk Artist Mattie Lou O'Kelley . . . a late bloomer going strong." *Early Years/K–8* (October 1984), pp. 26–27.

Rhodes, Lynette I. *American Folk Art from the Traditional to the Naive*. Cleveland: Cleveland Museum of Art, 1978, p. 101, works illustrated as cat. nos. 68–69 on pp. 102–103, with entries on p. 115.

Robertson, Jane D. "Mattie Lou O'Kelley: A Nostalgic Glance at the Past." Master's thesis, Hollins College, 1989.

Rosenak, Chuck and Jan. *Museum of American Folk Art Encyclopedia of Twentieth-Century American Folk Art and Artists*. New York: Abbeville Press, 1990, pp. 228–229.

Vlach, John Michael. *Plain Painters: Making Sense of American Folk Art*. Washington, D. C.: Smithsonian Institution Press, 1988, p. 169.

Wadsworth, Anna. *Missing Pieces: Georgia Folk Art, 1770–1976*. Atlanta: Georgia Council for the Arts and Humanities, 1976.

Book Reviews

Lind, Judith Yankielun. Review of *Mattie Lou O'Kelley: Folk Artist*, by Mattie Lou O'Kelley. *Library Journal*, CXIV (November 1, 1989), pp. 86–87.

Review of *Circus!*, by Mattie Lou O'Kelley. *Publisher's Weekly*, CCXXX (October 31, 1986), p. 66.

Review of *Moving to Town*, by Mattie Lou O'Kelley. *Publisher's Weekly*, CCXXXVIII (August 30, 1992), p. 82.

Review of *A Winter Place*, by Ruth Yaffe Radin. *Publisher's Weekly*, CCXXVIII (November 1, 1985), p. 66.